Step-by-Step

Clay Modeling

Greta Speechley

Heinemann Library
Chicago, Illinois

Published by Heinemann Library, an imprint of Reed Educational & Professional Publishing, 100 N. LaSalle, Suite 1010 Chicago, IL 60602 Customer Service 888-454-2279 Visit our website at www.heinemannlibrary.com

All rights reserved. No part of this publication may be reproduced or transmitted in any form or by any means, electronic or mechanical, including photocopying, recording, taping, or any information storage and retrieval system, without permission in writing from the publisher.

Readers are permitted to reproduce the patterns in this publication for their personal use.

Photographs and design copyright © Search Press Limited 2000

Text copyright © Greta Speechley 2000 Originated by Graphics '91, Singapore Designed by Search Press Printed in Italy by L.E.G.O.

05 04 03 02 01 10 9 8 7 6 5 4 3 2 1

Library of Congress Cataloging-in-Publication Data

Speechley, Greta, 1948-

Clay modeling / Greta Speechley.

p. cm. -- (Step-by-step)

Includes bibliographical references and index.

ISBN 1-57572-326-3 (library binding)

1. Modeling--Juvenile literature. 2. Clay--Juvenile literature. [1. Modeling. 2. Clay. 3. Handicraft.] I. Title. II. Step-by-step (Heinemann Library)

TT916 .S66 2000 731.4'2--dc21

00-038890

Acknowledgments

The author and publishers are grateful to the following for permission to reproduce copyright material: Bridgeman Art Library, p.5.

Photographs: Search Press Studios

Every effort has been made to contact copyright holders of any material reproduced in this book. Any omissions will be rectified in subsequent printings if notice is given to the publisher.

Some words are shown in bold, **like this**. You can find out what they mean by looking in the glossary.

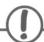

For my family: my daughter Thea,

who has brilliant ideas; my son Jess,

who has no idea; and my husband

David, who is my "big" idea!

When this sign is used in the book, it means that adult supervision is needed.

REMEMBER!

Ask an adult to help you when you see this sign.

Contents

Introduction 4

Fish Tile 22

Glossary 32

Materials 6

Treasure Box 24

More Books to Read 32

Techniques 8

Pencil Holder 26

Lion Dish 28

Index 32

Wobbly Pot 12

Fat Cat 14

Swinging Tiger 16

Flower Pot 18

Squiggly Bowl 20

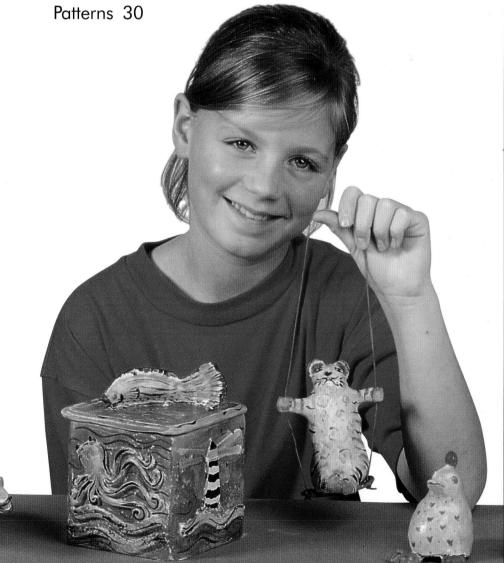

Introduction

People have been modeling clay for thousands of years, and pottery fragments have been found that date back as far as 1200 B.C. These early pots were baked in bonfires, and because the heat was not very intense, they were very fragile. As a result, only broken pieces of some of the **vessels** have survived to the present day. Some pots and models have been discovered in tombs and burial places, and you can see wonderful collections of these in many museums. Lots of these ancient vessels were highly decorated with painted figures and animals, which tell wonderful stories of how life used to be. The methods used by craftspeople in those far-off days were simple. Items were hand-modeled and molded into useful and decorative shapes, just like they are today.

I have taken my inspiration from nature, the world around us, and the simple techniques used by our ancestors to show how easy it is to create colorful and fun models, zany pots, crazy containers, and painted tiles. Each project shows a different way of using clay and suggests how you can paint your finished pieces with poster or acrylic paints. You might want to copy each one exactly to start, but I am sure that once you have done this, you will want to create your own unique pot or model.

It is a good idea to start using a sketch book or to keep a scrap book so that you can keep a note of the colors you like and use them on your models. Cut out bits of fabric or pictures from magazines. Think about texture—do you want a smooth finish, or would you prefer a rough surface? Look at pottery and sculpture from different countries and decide which you prefer. My favorite pieces come from Mexico and South America. I love the little figures and curious animals that cover these pots, and they are always painted in such lovely **vibrant** colors.

I have used air-drying clay for all the projects in this book. It is easy to use and is available from most craft stores. There are quite a few different types. Try to find clay that is soft when you poke it, rather than hard. Clay is wonderful to work with. If it does not look quite right, you can just squash it up and start all over again, and it can be used to make almost anything. I am sure you will come up with lots of ideas of your own and have great fun clay modeling. The only limit is your imagination. Have fun!

Note If you have access to a **kiln**, you can use real clay for all the projects except the solid swinging tiger on pages 16—17. You must ask an adult to use the kiln for you.

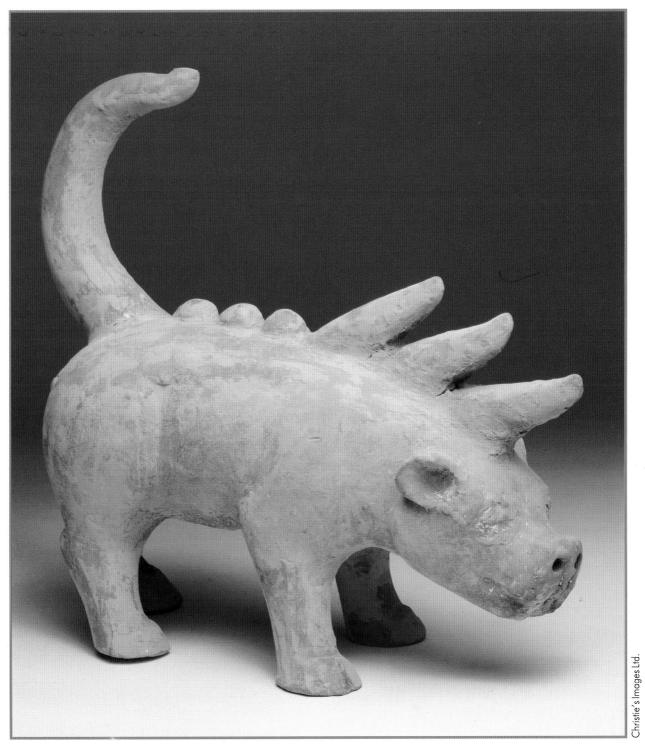

No one knows who made this pottery mythical beast, but whoever did was very skillful because he or she succeeded in making a simple model look almost life-like. The model, which is about 11³/₄ inches (30 cm) long, was made in China over 1,500 years ago, when the country was ruled by the emperors of the **Han dynasty**.

Materials

Apart from clay itself, many of the things you need to get started on clay modeling can be found in your own home. Clay can be messy, so it is a good idea to work on a wooden surface or cover your work space with a plastic cloth.

Air-drying clay is used for the projects in this book. You can buy it in packs at craft stores. If it starts to crack and crumble when you are modeling with it, wrap it in plastic wrap with a few drops of water and it will soften up. The manufacturer's instructions will tell you how to dry and harden it.

Sponges are used to smooth and finish a clay surface, and to paint finished models.

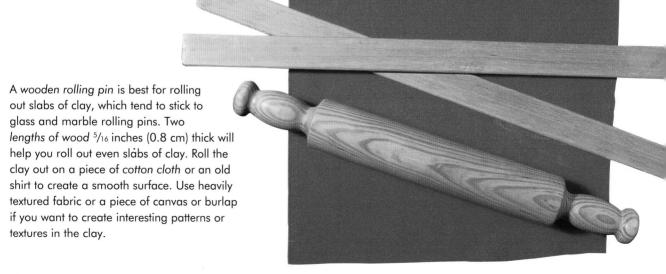

Clay squeezed though a garlic press or strainer makes lovely "hair" for your models.

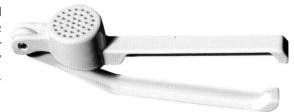

Cookie cutters can be used to cut out whole shapes or to create surface patterns on clay.

A small kitchen knife is used to cut out clay shapes. Ask an adult to help you do this.

A palette is useful for paints, but an old plate will do just as well. Acrylic paints are ideal for painting your models and they come in a huge range of colors. Acrylic paint is tough, it dries to an attractive sheen, and it does not need to be varnished. If you decide to use poster paints instead,

you will need to seal the clay surface with an acrylic varnish.

Some clays come with recommendations about what paints and varnishes to use, so read the instructions carefully.

Patterns at the back of the book can be photocopied onto paper. Use scissors to cut them out. A ruler and pencil are useful for measuring and drawing straight lines. A pencil can also be used to create lines and texture in the clay.

N

Paint can be applied
with a paintbrush or a
sponge. A stiff paintbrush or
old toothbrush can be used to
create a random spattered effect.

Plastic wrap is used to line molds to keep the clay from sticking to them.

Techniques

Clay is really easy to work with. You can model straight from a ball of clay, you can coil up long thin snakes, or you can make flat slabs that can be used to build boxes and containers. Practice these techniques before you start the projects.

Pinching out shapes

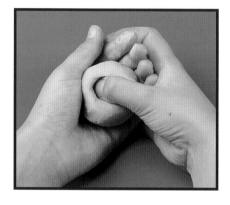

Note Before you start working on a project, always soften the clay by **kneading** it in your hands.

This very simple modeling technique is great for making small pots and bowls, and for modeling animals.

Hold a small ball of clay in one hand and press your thumb into the clay to make a hole.

Gently squeeze the clay between your thumb and fingers, and work evenly around the ball of clay to open up the shape. Stop from time to time to see how your shape is progressing.

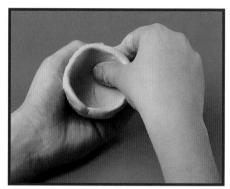

Rolling coils

You can use long clay snakes (coils) to build pots of any size and shape. The coils are made by rolling out the clay with your hands. For small pots, coils need to be about the thickness of your finger. Make them a bit thicker for larger pots.

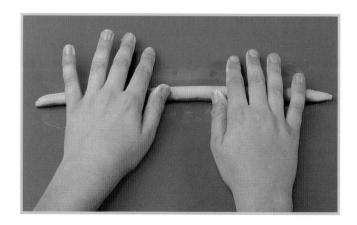

Making slabs

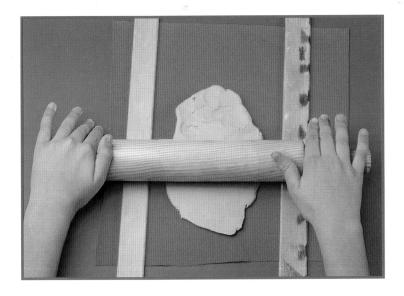

Flat slabs of clay can be used for tiles or for building boxes and containers. You will need a piece of cotton cloth (an old cotton sheet is ideal), a rolling pin, and two lengths of wood. Place a ball of clay between the wooden lengths and flatten it with the rolling pin. The thickness of the wood controls the thickness of the slab.

Note It is much easier to roll out several small slabs than to try and roll out one huge one.

Cutting out shapes

Knives are sharp. Ask an adult to help you cut out the shapes.

Use a paper **template** and a knife to cut out your design. Let it harden slightly before moving it, otherwise you might stretch the shape.

You can use cookie cutters to make fun shapes that you can attach to your pots.

Creating patterns

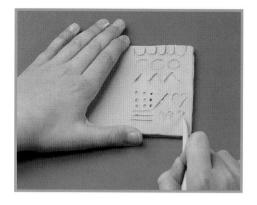

Wonderful patterns can be made in slabs of soft clay by rolling the clay over textured cloth or leaves, for example. Designs can be scratched into the surface with a modeling tool, the end of a pencil, or even a stick. You can also press objects into the clay to make patterns.

Joining and attaching

When joining coils or attaching small pieces of clay to larger pieces, the clay surfaces should be **scored** and moistened with water before being pressed and smoothed together. Allow all slab pieces to harden slightly first so they do not lose their shape.

Note Pieces of air drying clay can be glued together with strong glue if you decide you want to add something to your model or pot after it is dry.

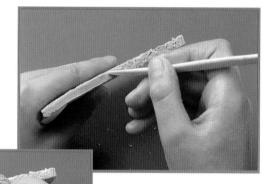

Use a modeling tool to score (roughen) all the edges to be joined.

Moisten the scored edges with a damp sponge.

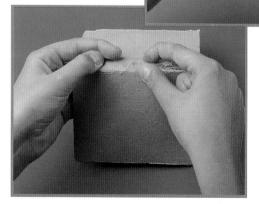

3

Press the two edges together firmly. Then use your fingers or a modeling tool to smooth the **joins**.

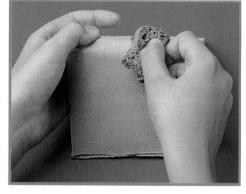

Finally, use a damp sponge on large pieces to create a really smooth finish.

Drying and painting

Before you paint your model, allow it to dry completely. The manufacturer's instructions will tell you how long you should wait, although it does depend on how warm your working environment is. If it is cold or damp, the drying time will be longer. Some instructions may tell you that you can speed up the process by drying the clay in the oven. This will harden the clay completely and make it more durable, but only do this if the instructions say so, and always get an adult to use the oven for you.

Note Acrylic paints dry very quickly and paintbrushes and sponges must be cleaned immediately after use or they will be ruined.

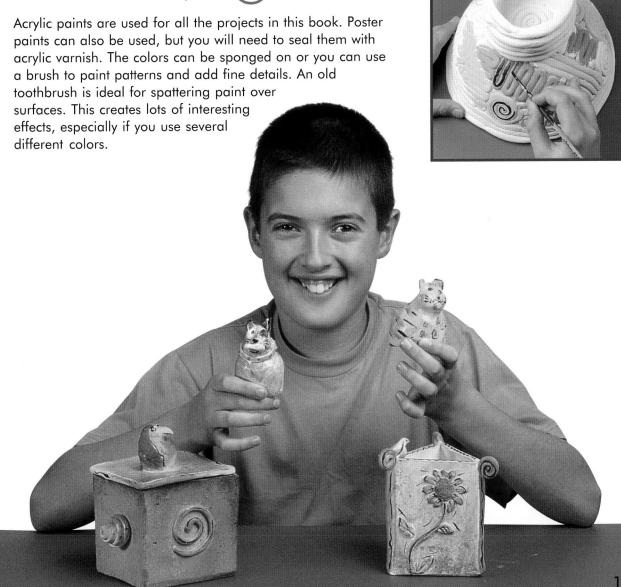

Wobbly Pot

The pinching technique can be used to make a simple pinch pot like the one featured in this project. Throughout time, and in many different cultures, this style of pot has been used for various purposes. A good example is the **diva pot** used to hold small lights during the Hindu festival of **Diwali**.

YOU WILL NEED

Air-drying clay Sponge Modeling tool Acrylic paints Paintbrushes

Use the pinching technique from page 8 to create a simple pot shape.

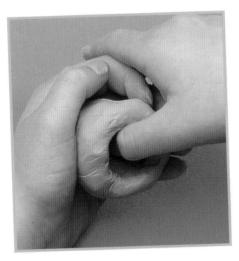

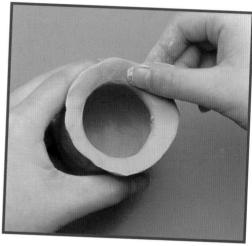

Squeeze the top of the pot to create a wavy edge. Leave it for half an hour to dry slightly.

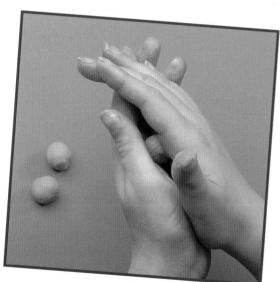

Roll three small balls of clay to attach to the bottom of the pot.

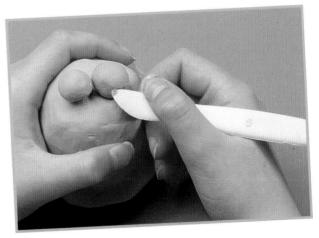

Score and moisten the surfaces to be joined, and gently press each ball onto the base of the pot to form "feet." Smooth around the **joins** with a modeling tool. Let the pot dry.

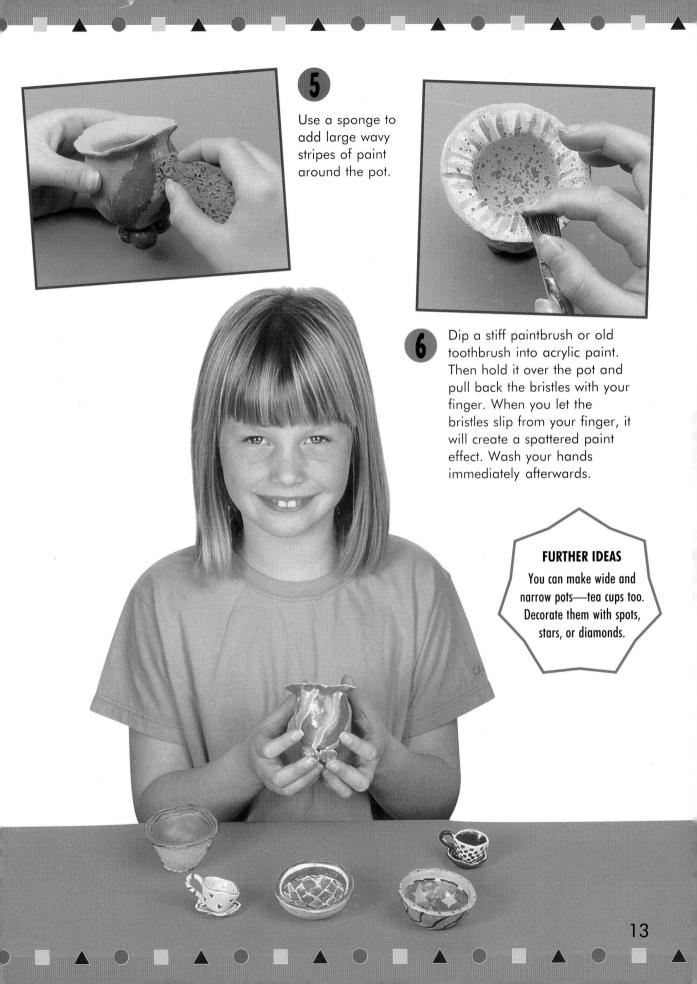

Fat Cat

In this project, coils of clay are used to make the collar, flower, and tail for the cat. The eyes and ears are pinched out of small amounts of clay. Animal sculptures by the artist **Picasso** could be used as inspiration. You can model lots of animals by just squeezing and stretching the basic pinch pot.

YOU WILL NEED

Air-drying clay Sponge Modeling tool Acrylic paints Paintbrushes

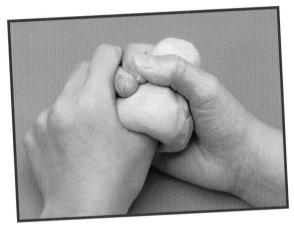

Make a basic pinch pot, as on page 8.
Turn it upside down and gently shape the head with your thumb.

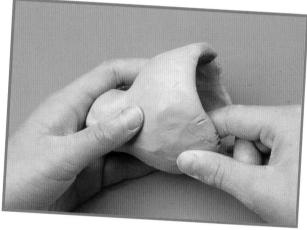

2 Squeeze the sides of the body, making it larger than the head. Shape the head to make a nose and cheeks.

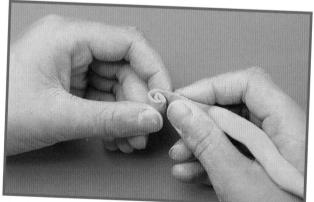

Roll out a coil of clay and flatten one end.
Loosely wrap the flattened clay and pinch off the end to form a flower head. Neaten the edge.
Use the rest of the clay to make a collar and tail from coils. Make ears from flattened clay and roll two small balls for eyes.

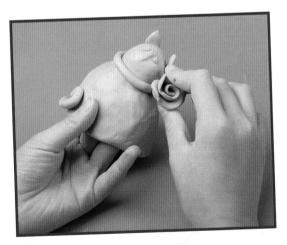

Attach the eyes, ears, tail, and collar to the cat. Add the flower to the collar by following the steps on page 10.

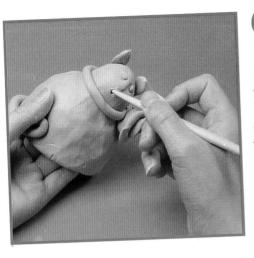

Use a pointed modeling tool to make a neat hole for the cat's mouth. Let the clay dry.

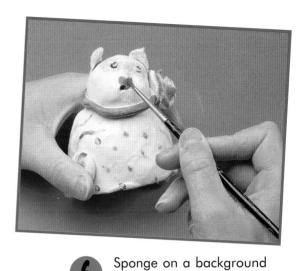

Swinging Tiger

Fun models like this tiger can be made from a solid lump of clay. Instead of pinching the clay into a pot shape, you simply roll it out and pull out the arms and legs. Remember that the more clay you use, the longer it will take to dry. The smooth, pinched shapes of these models resemble the shapes of some African and Mexican sculpted creatures.

YOU WILL NEED

Air-drying clay Modeling tool Sponge • Acrylic paints Paintbrushes String or garden wire

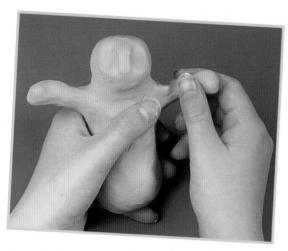

Roll out a fat clay sausage, shape a head and nose, and then carefully form two arms by pulling clay from the sides of the body.

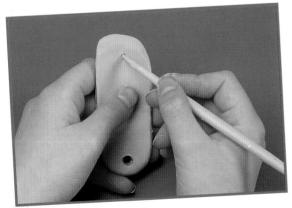

Model the swing seat from a slab of clay. Use the point of the modeling tool to make two small holes for the string or garden wire.

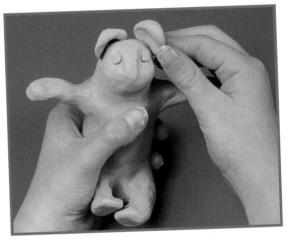

Model the bottom of the body and bend the legs out towards you. Add eyes and ears.

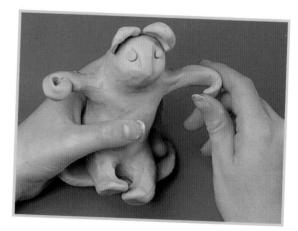

Attach the tiger to the seat. Bend the ends of its arms to form hands, leaving a hole in the middle of each for the string or garden wire to be pulled through. Let the clay dry.

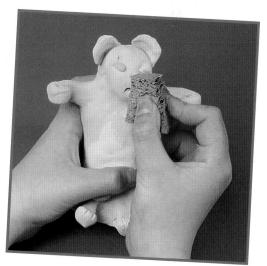

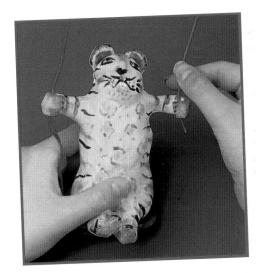

Thread the string or garden wire through the hands and seat, and knot the ends.

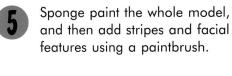

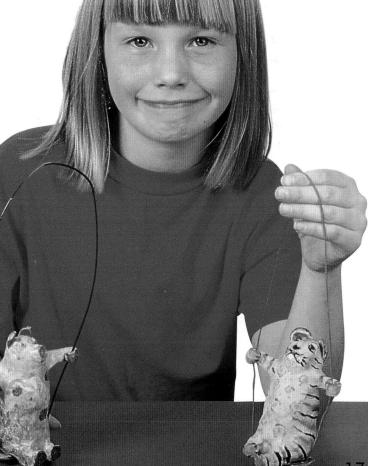

Flower Pot

The technique of coiling is ideal for building up round symmetrical shapes like these flower pots. If you want your pot to be perfectly even, it is important to keep the coils the same thickness and to continually turn the pot as you join and smooth the coils together. Look to artists and sculptors for ideas about what to paint on or mold into the clay to decorate the flowerpot. Inspiration for the flowers could be taken from famous paintings such as Van Gogh's Sunflowers.

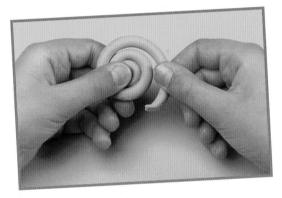

Roll out a coil of clay and use it to make a base. Smooth the coil flat.

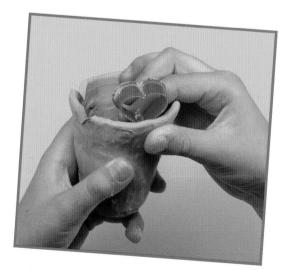

When the pot is tall enough, smooth the top of the rim. Then use part of a cookie cutter to create a fancy edge.

YOU WILL NEED

Air-drying clay
Modeling tool • Cookie cutter
Garden wire
Pebbles • Moss
Acrylic paints
Paintbrushes

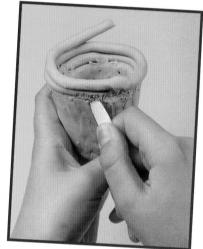

Start to build up the walls of the pot using long, thin coils. Smooth the inside and outside surfaces with a modeling tool as you work upwards.

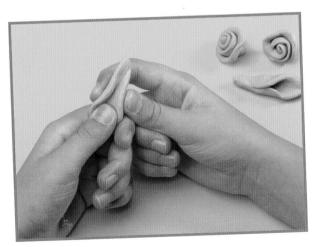

Roll out a piece of clay and use the technique shown on page 14 to make small flower heads. Squeeze pieces of clay between your fingers and model them to form longer flower heads.

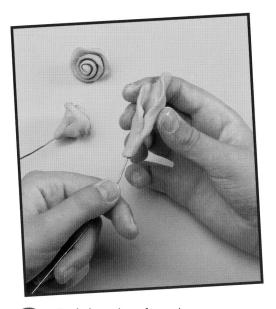

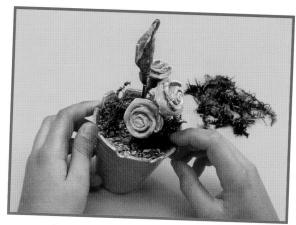

Paint the flowers and pot and leave them to dry. Arrange the flowers in the pot and use small pebbles to hold the wire stems in position. Finally, cover the top of the pebbles with some moss.

19

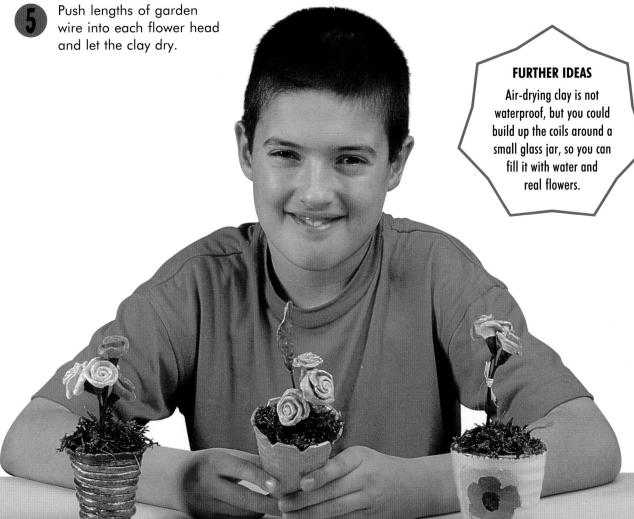

Squiggly Bowl

Coil pots were made by some ancient cultures. The coils provide an instant decoration which can be painted in vivid colors. By using different thicknesses of coil and varying the shape of the coil, you can experiment to produce different patterns and textures. In this project, a bowl lined with plastic wrap acts as a mold. Coils are built up on the inside of the bowl. You can use any shape as a mold as long as the top is wider than its base so it is easy to remove the finished piece.

YOU WILL NEED

Air-drying clay
Mold (bowl)
Plastic wrap • Sponge
Modeling tool
Acrylic paints
Paintbrushes

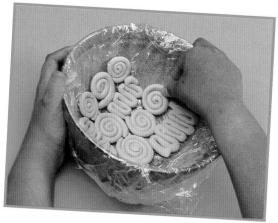

Line the inside of the mold with plastic wrap, and lay squiggles and coils of clay inside the bowl.

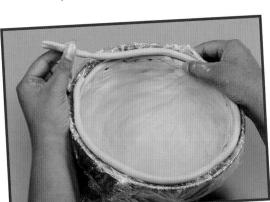

Lay two long coils of clay around the top of the bowl to form a rim. Allow the pot to harden slightly before removing it from the mold.

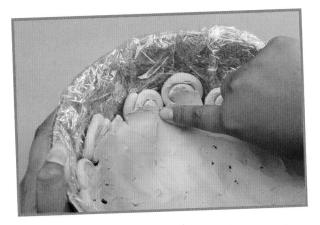

Join all the coils together by gently smoothing the inside surface with your fingers. Do not press too hard. You want the coil pattern to remain on the outside.

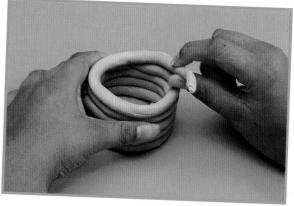

Make a base from long coils of clay. Smooth the inside of the coils together to make it stronger.

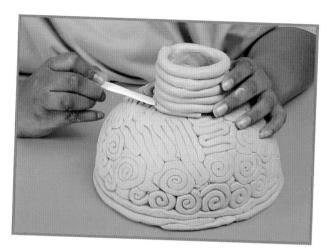

Turn the pot upside down and carefully attach the base. Gently smooth the **join** with a modeling tool or your finger.

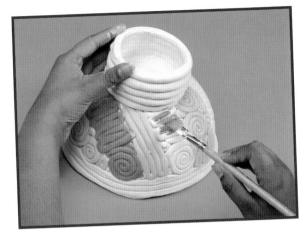

Allow the pot to dry completely, and then paint the coils.

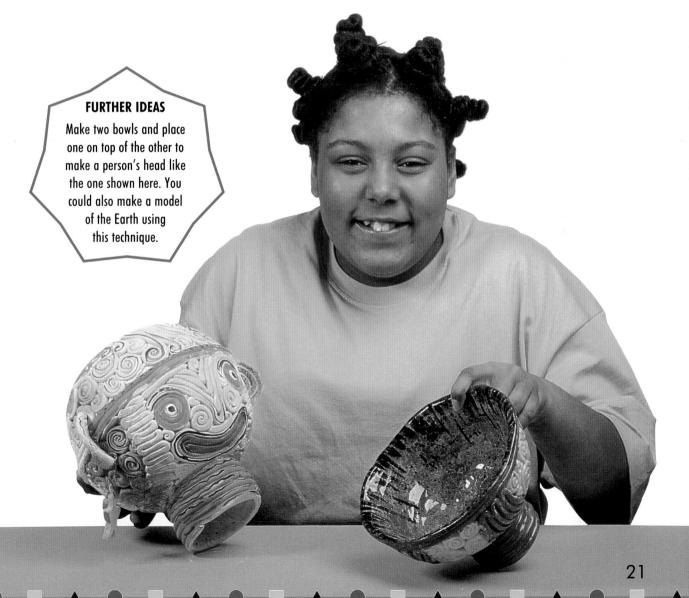

Fish Tile

The simple tile in this project is created by rolling the clay into a slab and then decorating it with cut-out shapes and paint. Look for different examples of tiles for inspiration. You may find them in your own home, or in many religious buildings. You can also look at the work of the Spanish artist **Gaudi** to see all the amazing things that can be done with tiles.

YOU WILL NEED

Air-drying clay
Knife • Rolling pin
Two lengths of wood • Sponge
Modeling tool • Acrylic paints
Paintbrushes • Scissors
Piece of wood

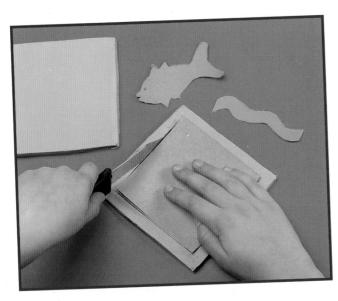

Photocopy the square, border, fish, and wave patterns on page 31. Cut them out and then place them on a slab of clay. Use a knife to cut around the shapes and set them aside to harden slightly. Roll a few tiny balls of clay to form bubbles.

Knives are sharp. Ask an adult to help you cut out the shapes.

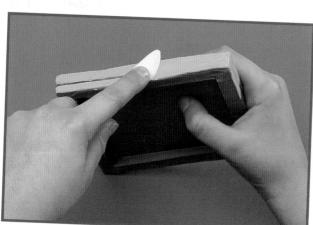

Attach the border to the square base by following the instructions on page 10. Smooth the edges of the **joins** with a modeling tool.

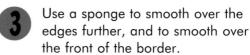

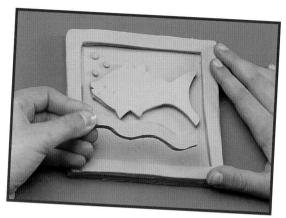

Attach all the pieces to the tile. Let it harden slightly. Then place a piece of wood on top to keep everything flat. Let it dry thoroughly.

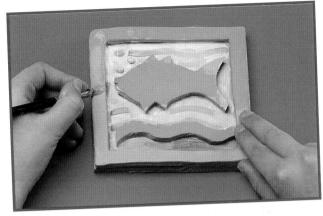

Paint the sea first, and then apply a base color to the fish, the wave, and the border.

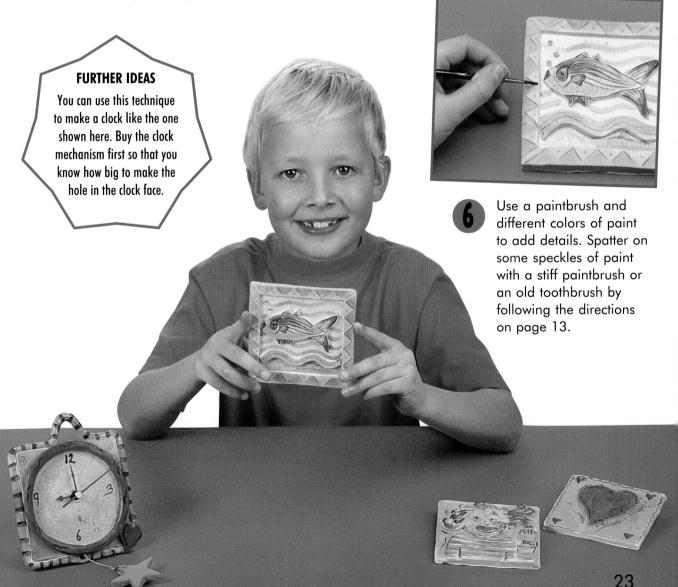

Treasure Box

The decorations for this box are attached by scoring and moistening the two pieces of clay and joining them together. You could also explore other methods of decoration such as carving shapes using modeling tools.

YOU WILL NEED

Air-drying clay
Knife • Rolling pin
Two lengths of wood
Modeling tool • Sponge
Acrylic paints
Paintbrushes

Photocopy the square patterns for the Treasure Box on page 31, and cut them out from slabs of clay. Allow the slabs to harden slightly. Then use a modeling tool to **score** the surfaces that will be joined.

Knives are sharp. Ask an adult to help you cut out the shapes.

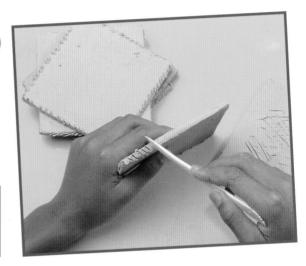

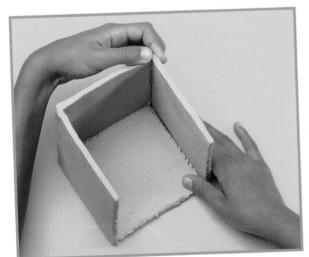

Moisten the edges with a sponge and assemble the box as shown, with the scored edges touching one another.

Leave off one side for the moment. Pinch and squash the clay pieces together and smooth over the outer **joins**.

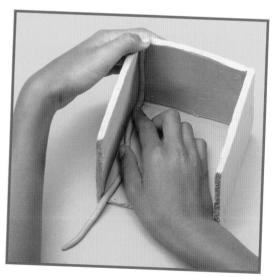

Roll out long thin coils, and then press and smooth these over the inside joins to strengthen them. Attach the remaining side and carefully strengthen the join with a coil.

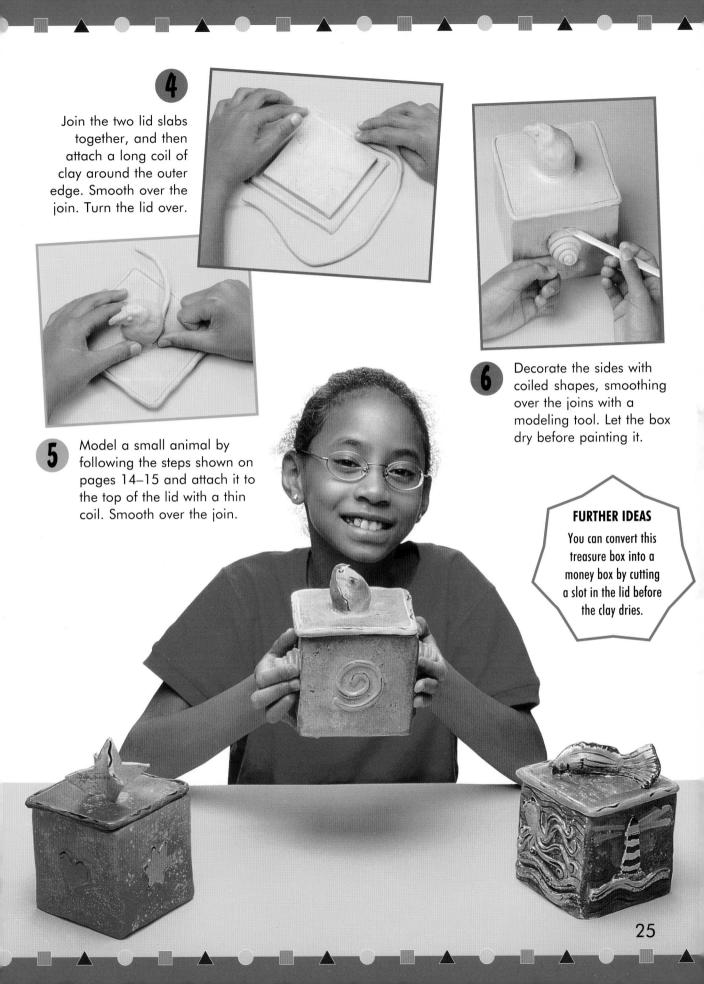

Pencil Holder

Clay is an important material in making everyday things. It is also useful for making **decorative** ornaments. The techniques used in this project are the same as those for the Treasure Box on pages 24–25, but the **joins** are strengthened on the outside rather than the inside.

YOU WILL NEED

Air-drying clay
Knife • Rolling pin
Two lengths of wood
Modeling tool
Cookie cutters • Sponge
Acrylic paints
Paintbrushes

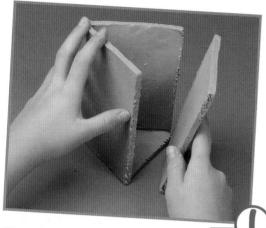

Photocopy the patterns on page 30, and cut them out from slabs of clay. Allow the slabs to harden slightly, and then assemble the triangle and three rectangles to form the basic shape.

Knives are sharp. Ask an adult to help you cut out the shapes.

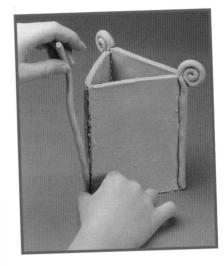

2

Roll out three long coils of clay, and smooth them on the outside edges to strengthen the joins.

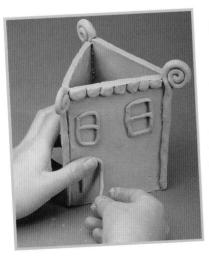

3

Decorate one side of the pencil holder. Use thin coils of clay to create windows, roof tiles, and a door.

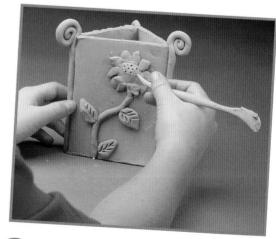

4

Use a coil and small pieces of clay to add a sunflower on one of the other sides. Use a pointed modeling tool to add details such as veins on the leaves and seeds on the flower head.

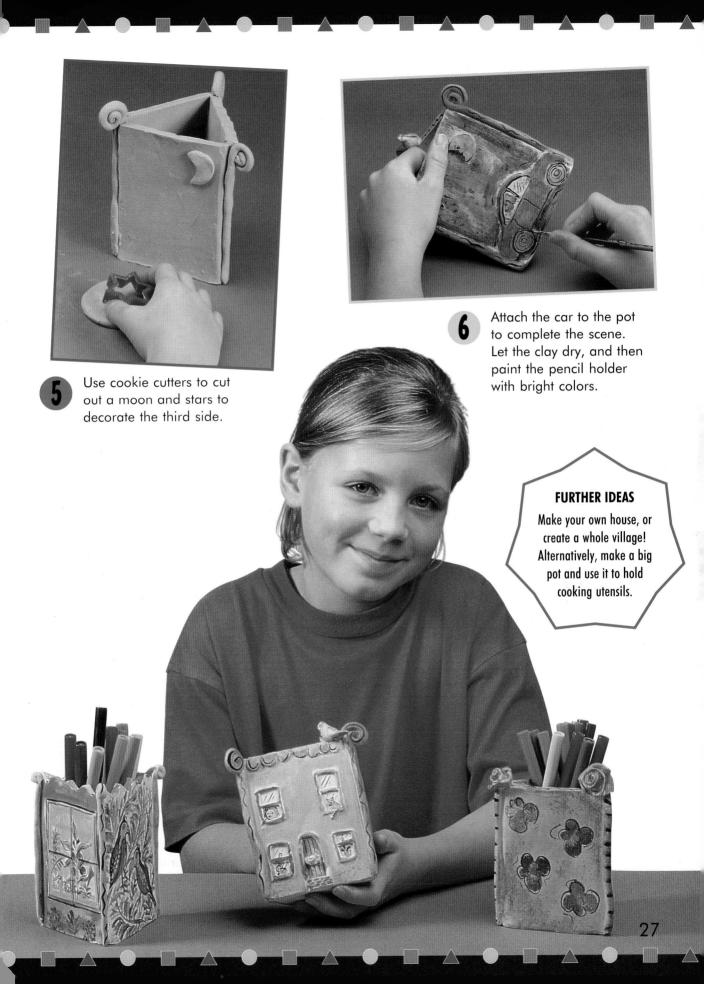

Lion Dish

Your imagination can really run wild with this dish. This shows you how to make a lion, but all kinds of shapes can be used to make a variety of fantastic creatures. Use a mixture of decorative techniques to finish it off, including molding, attaching clay shapes, and creating patterns using clay tools.

YOU WILL NEED

Air-drying clay
Rolling pin • Two lengths of wood
Mold (dish) • Plastic wrap
Sponge • Modeling tool
Garlic press or strainer
Acrylic paints
Paintbrushes

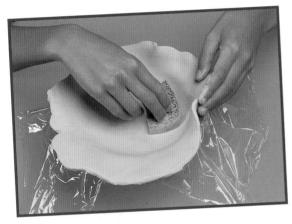

Cover the mold with plastic wrap.
Roll out the clay, and lay it over the mold. Gently press the clay down using a sponge.

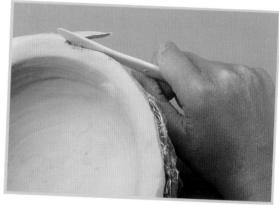

Trim off excess clay with a modeling tool. Allow the clay to harden slightly, and then remove it from the mold.

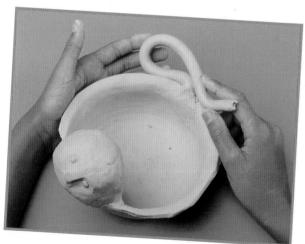

Form a head and tail and attach them to the rim of the dish. Shape two ears and attach them to the head. Smooth over the joins with your fingers.

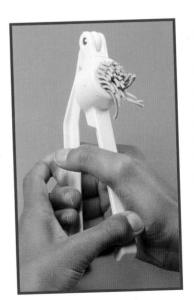

Squeeze a ball of clay through a garlic press or strainer to create the lion's mane and tail.

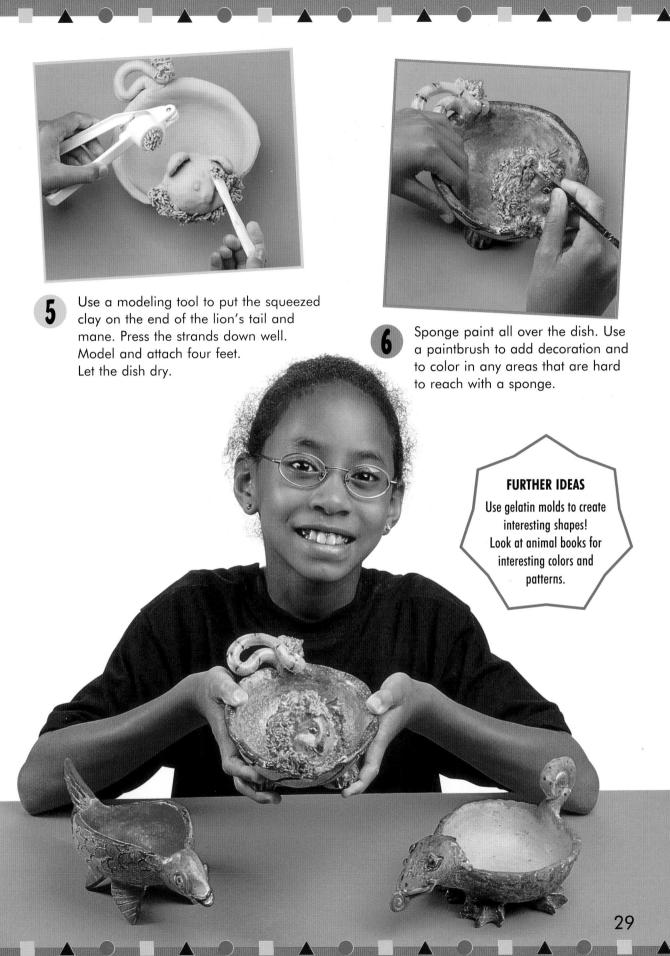

Patterns

The patterns on these two pages are the size that I used for the projects, but you can make them larger or smaller on a photocopier if you wish. Once you have photocopied the patterns, you can cut them out, place them over your clay, and cut around the outline with a knife.

Get an adult to help you photocopy the patterns.

You will also need an adult to help you cut out the clay shapes.

These patterns are for the Pencil Holder shown on pages 26–27. You will need three rectangular slabs of clay, one triangular slab, and one car shape.

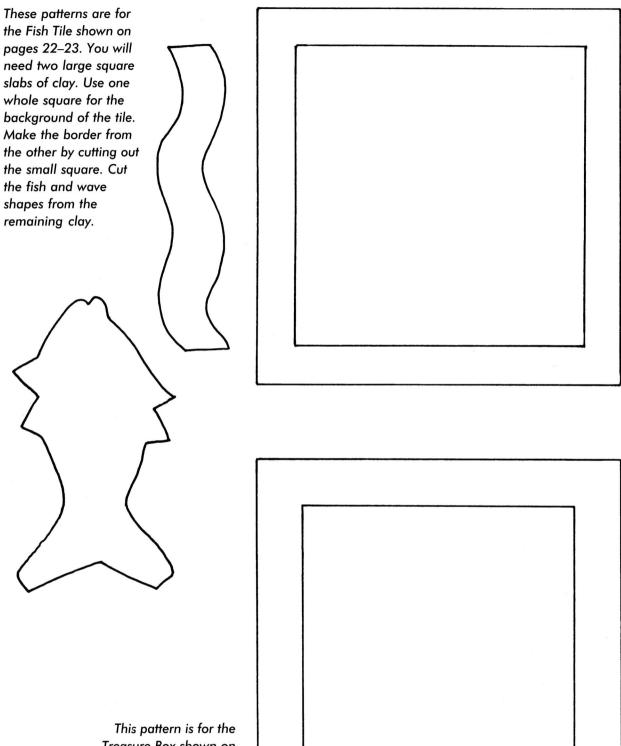

This pattern is for the Treasure Box shown on pages 24–25. You will need five large square slabs for the actual box, and one large and one small square slab for the lid.

Glossary

Decorative something made purely for the way it looks

Diva pot small earthenware lamps filled with oil and placed in rows in front of temples and homes, and set floating in rivers and streams during the Indian festival of Diwali

Diwali major religious festival in India spanning a five day period in late October that honors the Hindu goddess of wealth, Laksmi

Fragment piece of part broken off from a whole object

Gaudi, Antonio Spanish architect whose style of designing buildings is known for bold colors and textures

Han dynasty period of Chinese history that spanned from 206 B.C. and A.D. 220 during which art was highly encouraged and valued

Join seam; place where two or more objects come together; place where two pieces of clay are attached

Kiln oven that bakes pottery, or clay, at very high temperatures

Knead to press and squeeze for several minutes

Picasso, Pablo Spanish artist, considered to be one of the most influential artists of the twentieth century, who created paintings, sculptures, and stage sets

Scored, score to make the surface rough by carving lines, notches, and rough patterns in it

Symmetrical well-proportioned or the same on both sides

Template pattern or guide for copying an image once or many times

Van Gogh, Vincent Dutch painter known for his unique painting style, which used bold colors and strong, obvious brush strokes in thick paint

Vessel hollow utensil or dish such as a bowl or cup or anything used to hold water or other liquids

Vibrant colors that are bright, lively and exciting

More Books to Read

Hull, Jeannie. *Clay.* Danbury, Conn.: Franklin Watts, Inc., 1989.

Moniot, Janet. Clay Whistles—The Voice of Clay. Petal, Miss.: The Whistle Press, 1990.

Newby, Nicole. Cool Clay. Mahwah, N.J.: Troll Communications, L.L.C., 1996.

Schue, Lori V. Clay. Monterey, Cal.: Evan Moor Corporation, 1995.

Index

Africa 16 animals 4, 5, 14, 15, 25

cat 14-15 lion 28-29

mouse 14

penguin 14

tiger 16-17

bowls 8, 20-21

boxes 8, 9, 24-25

China 5

clock 23

dishes 28-29

diva pot 12

Diwali 12

Earth 21

flower pot 18-19

flowers 14, 18, 19, 26

Gaudi 22

Han dynasty 5

house 26

Mexico 4, 16

money box 25

pencil holder 26-27

Picasso 14

South America 4

texture 4, 6, 7, 10,

20

tiles 4, 9, 22-23

Van Gogh 18